BEYOND THE FAIRWAY

BEYOND THE FAIRWAY

Timeless Images from Legendary Golf Photographer Paul Lester

First Edition

PAUL LESTER

An Ultimate Books
Belleair, Fl

Published by Ultimate Books, 415 Belleview Blvd, Belleair, Fl 33756, 818-448-9694.

ISBN: 978-0-9635097-3-4

Book Design and Electronic Production: Creative Publishing Book Design
Contributors: Pat Anderson, Abbigail Remkus
Cover Photograph: Paul Lester

Manufactured in the United States of America.

This book is dedicated to my father, Buddy Lester.
Thanks Dad for starting me in Golf.
Which kept me from shooting weddings.
And to my daughter and best friend, Jillian.
You are my life.

Contents

Acknowledgements

Buddy and Lael Lester

Jillian Lester

Robin Lester

Brenda Remkus

Judd and Linda Swarzman

Melinda Richman

Barry Richman

Leroy and Carole Richman

Silvia and Bob Jensen

Steven and Stacey Jensen

Lois and Glenn Dunlap

Abbigail Remkus

Bruce Macleod

Tiger Woods Foundation

The Riviera Country Club

Sherwood Country Club

Bel Air Country Club

Brentwood Country Club

Wilshire Country Club

El Caballero Country Club

Palos Verdes Golf Club

Braemar Country Club

Pacific Palms

PGA West

IMG

ESPN

Mel Miller

Don Ohlmeyer

Dave Podas

Joe McClellan

Chris Ohlmeyer

Terry Jastrow

Roy Firestone

Steve Beim

Paul Spengler

Melinda Thomas

Chuck Gerber

Tony Renaud

Chris Jurgenson

Michael Yamaki

Gary Zietlow

Bryan Naugle

Arthur Bernier	Eddie and Lisa Merrins
Paul Singer	Ken Marinace
Doug and Linda Wonderly	Judy and Yippi Rankin
Dave and Linda Hofman	Barry Kapelowitz
Barry Frank	Dave and Dave Marr Jr.
Jane Wandmacher	Bob Auerbach
Stan Wood	Warren Seltzer
Mike Galeski	Brian Robin
Steve Brener	Scott Halleran
Ron and Kay Masak	Sarah Shmerling

To all the PGA professionals and the Tour professionals and their Caddies:
Thank you for an amazing life in the best game of them all,
GOLF.
Love you all.

Special Acknowledgment

I can't find all the words to thank my friend, his inspiration for this book, and the best golf performance instructor in the world, Bob Cisco.

Thanks for helping me realize another dream, Bobby.

Foreword

Sitting in the booth next to great analysts like Tony Romo, Sir Nick Faldo, Grant Hill, and Bill Raftery, I often marvel at what they see that I don't see. It's a gift that they bring to their audience every broadcast. It's a sixth sense.

My occupation has put me in the company of legends. And I'm not just talking about the athletes and the broadcast partners I'm honored to sit alongside.

Paul Lester has been a friend for countless years. Our paths have crossed at the biggest events in sport. We travel in the same circles for charity events and corporate functions. When I see Paul, I know that I'm stepping into what will be a memorable and special occasion. For you see, much like the Palmers, Nicklaus's, Woods, and many others who have gained legendary status, Paul Lester is an icon in the world of photography.

Paul has that sixth sense to capture a moment at the precise time. He has that natural knack and nuance to be in the right place, when no one notices, to bring home the "victory" shot that brings clarity to what could otherwise be a flicker of history lost.

In addition, I've watched Paul interact for years with royalty – like the King, Arnold Palmer – or the layman who is watching something pivotal from off to the side. He has a gift to make every member of his universe feel important, to bring kindness and joy to everyone he touches.

Imagine dedicating your life to documenting everyone else? Some may think it's a skill that is acquired. But in Paul's case, I believe he was born with an enormous talent. Through his prism, he has captured many of the most candid and glorious snapshots you will ever see.

You are about to take a journey that is a half century in the making. The best of the best, allowing us to look into his world.

Enjoy the ride and the company of the great Paul Lester!

Jim Nantz

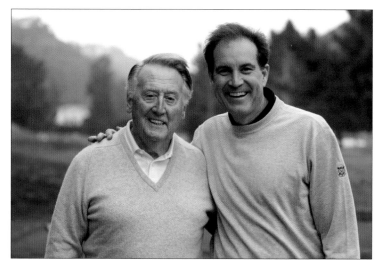

Vin Scully and Jim

Introduction

"The key to creating a book that people appreciate is to give them something special. That is exactly what our dear friend, Paul Lester, has done in his book." – *Beyond the Fairway.*

Having received and enjoyed many of Paul's photos over the past 50 years – we knew that Paul was anxious to "highlight" some of his photos and to tell "his story" as to how he has managed to get where he is today. His idea was to take the reader on a journey, and that it be a journey that engages the reader with every turn of the page. The human eye likes variety.

Paul's approach is a mixture of art and documentary. Every time he picks up a camera, he discovers something new – and, he takes interesting pictures that tell the story he wants to tell – bringing his creative experience to the still image. Each and every photo that Paul has sent to Jack and me brings a story to life through his lens!! We treasure each one!

Paul is the best at getting the best photos ever!! All who meet him love him, and appreciate his talent – as well as his kindness, his concern, and his thoughtfulness!

Jack asked me to please mention that – "Paul has not only been a good photographer – but, more importantly – a good friend. I always enjoy my time with him. PS we have a great time 'kidding' with each other!"

Remember – if pictures can talk – let them. Paul's pictures do just that!

Barbara Nicklaus

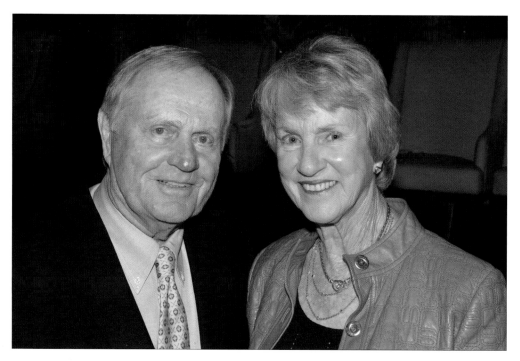

What a couple, Jack with the First Lady of Golf. Barb is so special. Never forgets a name. Loved by all.

The Paul Lester Story

Part I: Through the Lens of Paul Lester

Woodland Hills, California. It was a Friday night in 1970. I remember it well.

It was a windy semi-cold Friday night in November and I was off to a high school football game with my friend Doug.

The football team coach needed someone to take film footage and asked me to cover the game. There was just one catch. You have to go up the fifty-yard-line pole to do it. The coach asked, "Are you okay with that? It's fifty feet up the pole and we need footage of the entire game."

I said sure, especially when he said the athletic department would pay seventy-five dollars to do it. And so, being okay with heights, I obligingly went up the pole before the game with my trusty 8mm camera. There were small guide rails at intervals and the eventual goal at the top was a metal type basket you perched in to get the game footage.

You could see all around from the top of the pole. The intense bright lights covered the entire football field and high school stadium and out towards the parking lot.

I could make some good money doing this and the school's football team paid me for each game. So I started doing football games and being the go-to cameraman at each game. Three-hundred dollars a month in my pocket suited me just fine.

It was here I began to learn and hone my photography skills. I learned how to shoot and frame a shot and compose a picture.

Not bad. Friday night high school football was a big deal and teams filled up stadiums, having a good following from parents and alumni. And the traveling team's supporters were also there.

SO I GUESS I WOULD SAY MY CAMERAMAN AND PHOTOGRAPHY CAREER WAS BORN RIGHT THERE.

My Dad, (Buddy Lester) was an actor in Hollywood and had done a lot of films. He also liked golf. He would play in a lot of the celebrity charity events. So one day, as I recall, he said, "Why don't you come along and bring your camera and get some pictures of the event," which I did. I still didn't know all that much about cameras and photography and the like. But it all sounded good to me.

My idea was, when I was twenty years old, I wanted to work in the entertainment industry as a cameraman on the sets. My Dad had taken me on the set a number of times when I was younger and I always like being there.

The following summer he helped me get a job on the set but it was not doing camera work but was construction work at Universal Studios. I worked a jack hammer. That got a little old after about two years or so. This is Show Business!?

Taking pictures at some of the fundraising golf events my Dad played in got me thinking, and I decided to try other events in the area. I would take pictures of the foursomes on the tee – celebrity player and his playing partners. And I'd charge each golfer five dollars for a 5x7 picture which I would send to each player in the mail. And before I knew it I was doing a bunch of similar events in Southern California. I was onto something I liked doing and was making good money.

Pretty good stuff for me.

Not too long afterwards, I got a referral and started working for *Golf Illustrated* magazine. They would pay me ten dollars a roll for shots and gave me assignments to shoot unlimited amounts of pictures of pro players at the events in Southern California. This was very cool as I could shoot ten rolls easily and make a hundred dollars.

I went to the big tournaments' stops in Southern California, like La Costa for the Tournament of Champions, and many other key events in the California desert areas of Palm Springs.

I was sharpening my skills with the camera and this was working well for me. People in the industry and those I took pictures of all said I had just the right personality for being a photographer and they felt at ease with my approach.

It was Al Geiberger, who later became the first pro golfer to shoot 59 in a golf tournament, who befriended me and encouraged me in many ways. I took some great shots of him. This got me more known amongst the pros.

As I got to about the tenth year mark doing these golf events, I decided I really wanted to do more corporate golf events.

The door swung open more my way in the early 1970s when, having known Stan Wood, the famed University of Southern California golf coach, I began photographing the pros at big golf events on the PGA tour.

When Stan Wood left USC, he created his own public relations company for the PGA Tour and wanted me to shoot pictures for tour events. This was in the late 1970s and early 1980s. The LPGA was taking off as well, with great players like Amy Alcott, Nancy Lopez, Jan Stephenson, and Kathy Whitworth.

I became good friends with many of the lady touring pros especially Amy Alcott, Nancy Lopez, and Betsy King. And also with many of their caddies in those days, who were right on the scene with their players.

I was learning about people, their personalities, and how to respond to celebrities and golf stars.

It was a great time for golf. Golf was making its mark in the television and entertainment world as well as becoming the go-to sport.

Part Two: ESPN, the Skins Game, and Silly Season

It was Don Ohlmeyer in 1984, who started the Skins Game made for television. And, oh my goodness, what a hit it was. He was an executive producer for NBC Sports, which had started the successful Dinah Shore golf tournament. It was always in the spring and attracted top players and celebrities. I started with them one year later.

I had been doing the Dinah Shore tournament for several years already when the Skins Game came about, with the idea of having it on Thanksgiving weekend, nine holes each day on Saturday and Sunday.

It was awesome and was a big hit for television. Folks who were up north where it was already getting cold could view it played in sunny Palm Springs and it was such a big hit. Golf was on a rocket ride – it was the sport and place to be. And I was right in the middle of it.

With the advent of the Skins Game, I met many key people and sponsors in the industry. Toyota was a major sponsor then. They were involved with sports marketing and promotional campaigns for their new cars, and golf was definitely a big area for them.

The Skins Game then went to PGA West, a new golf development in the desert, and it was their association with the Skins Game that put PGA West on the map. Homes were sold right and left.

I was there for many of the events. I was there when Lee Trevino made the first ever hole in one on the 17th Island green, a long par three at PGA West. The place and television ratings went wild and golf was approaching its pinnacle of success and popularity.

It was all very exciting from my vantage point, being inside the ropes a lot and the only golf photographer at many of the banquets with the top pros and celebrities.

It was like being in another world, I can tell you that.

Because the PGA tour would be played from January to late August, players then had a few months off and could do a bunch of things, including going back home for a much needed rest and to see family. But there were a series of special made-for-television events that they could play in, and many did just that when they could.

It soon began to be called the Silly Season and there was a lot of fun stuff going on. It was more laid back, and these unofficial events were a big hit with television watchers.

These events included The Shootout at Sherwood, The Battle at Bighorn, and The Wendy's 3-Tour Challenge, which pitted key pros from each of the PGA Tours together in a competition: PGA, LPGA, and Champions Tour.

And there was the ABC special, the "Under the Lights" golf event on Monday nights, right before Monday night football. It was back in the fall lineup as a regular thing on network television.

I was amazed at how cool all this was. I got to be part of it as a photographer, getting wonderful pictures of it all.

ESPN TV was a big part of my life, as I photographed many of their events. Golf events, including the majors, were carried on ABC Sports, long before there was the Golf Channel.

Then Golf Channel bought the rights to broadcast the tournaments. It was always ESPN who had done them in those days.

There were other successful versions of the Skins Game, like the LPGA Skins Game and the Champions Tour.

The Champions Tour was, of course, the new name of the Senior Tour, and most of the players were all champions in their own right. This, of course, included golfing greats like Arnold Palmer, Jack Nicklaus, and Gary Player, golf's modern big three. Throw in Tom Watson, Lee Trevino, Raymond Floyd, and Curtis Strange, and you had barn-burner hits, great finishes, and all that money on the line. It was perfect for television golf.

Golf was nothing less than the where-its-at sport.

I was able to be behind the scene as well, at the banquets in the evenings, and I got to know many of the top players and their families. And it was really like a big family itself.

Golf was becoming the greatest of all photographed and televised sports on the planet and in its own element and thriving.

And I was in the middle of it all.

Part Three: The Present and the Future and Some New Stuff for Me

The majors were incredible to photograph and I was involved with many of them.

Besides doing my thing and getting pictures on the course, I went back and forth from the media centers throughout the day as press conferences and news updates became more available.

Masters week was very special for me. I took pictures on the course during the day. And at night I attended many of the corporate-sponsored events at the homes corporations rented all week for the Masters. Some of the bigger corporations brought their key sales people, managers, and customers during Masters Week. And they would bring in tour players or celebrities to make appearances and meet their clients. One of the Masters champions, Trevor Immelman, was there making an appearance the week he went on to win the Masters. He was a nice young man from South Africa with a picture-perfect golf swing.

But if you would ask me what the two biggest events in golf were, I would have to say, without a doubt, the Centennial of Golf Awards and the Nabisco Dinah Shore golf tournament.

The Centennial of Golf was a special awards event in New York City in 1989. The sponsor, *Golf Magazine*, honored the top one hundred golfers of all time. Jack Nicklaus received a special award for being recognized as the player of the century.

This event was like a who's who of all the top legends and celebrities who contributed to the game of golf. It included Sam Snead, Ben Hogan, Jack Nicklaus, Dinah Shore, Johnny Miller, Nancy Lopez, Arnold Palmer, Kathy Whitworth, Gary Player, Lee Trevino, and Jan Stephenson. You name it, they were there, all in one room. A very special occasion in golf history, I would say.

It was an honor to photograph this event. I got pictures of the players and the top celebrity people and I took many pictures of their families as well. These were all legends of the game and noticeable celebrities in the hall of fame of golf.

I began to know the player's families by their first names more and more.

I got some rare pictures of Hogan and Nicklaus. These were rare moments in golf and it was a pleasure to communicate with them from the lens of Paul Lester.

Corporate outings and the many fundraising golf tournament events were the mainstays of my golf photography business in those days and I did hundreds of these over the years. And my photography company continues to do so to this day.

I've been privileged to have been behind the scenes in golf all these years in many incredible moments and experiences. It has been my career ambition, livelihood, purpose, and LOVE.

The Ryder Cup was a big international competition and great for golf.

It was our turn to play against the Europeans. The United States team, captained by Corey Pavin, a good friend of mine, ventured across "the pond" to play in Wales. I got all kinds of pictures that week but the team photo I took of the U.S. team made me very proud to be an American. This was at Celtic Manor in Wales.

It was an incredible team event and the U.S. team spirit was amazing. Just goes to show you that team events like the Ryder Cup are perfect for television and the U.S. public like it a lot.

The Ryder Cup is an incredible event, like no other, and brings out loyalty and patriotism on both sides like you can't believe.

I was there watching all along, taking these pictures all those years, and with the incredible expansion golf went through. It was so exciting.

I have to say, when the big corporate sponsors were no longer involved with the Skins Game and Silly Season, and the Fed Ex End of the Year Tournaments came out, things changed in the golf world, especially here in the United States. The glamour faded and the glow has been hard to find in the world of golf as more and more successful things were changed.

The advent of the digital camera and the birth of social media also changed things in the golf world. Many would say it's not the same as it was in the glory and golden years that saw the likes of Golf's Big Three: Palmer, Nicklaus, and Player; Nancy Lopez and Amy Alcott; Trevino, Watson and Greg Norman; Chi-Chi Rodriguez and Fuzzy Zoeller; Doug Sanders, Annika Sörenstam, and JoAnne Carner. And of course there's no one like John Daly. The list goes on and on.

And then, in his own special category, there is Tiger Woods, perhaps the greatest player ever. Where from 1997 through 2005, because of Tiger Mania, three million new golfers entered the ranks of the game, many of whom were juniors, women, and underprivileged. At the height of Tiger Mania, there were thirty-seven million golfers in the U.S. and golf was king. Golf had expanded greatly and was an entire commerce in itself worldwide.

* * *

My career in the golf industry has spanned fifty years!

It's so hard to believe. It continues to amaze me. It was like yesterday for me. I recall many of the events in vivid detail. It was such a pleasurable experience for myself, my family, and company.

There are some excellent golf photographers. I can certainly acknowledge all of them. But I have had the longevity and personal relationships with the players. I have been there in many treasured moments.

I've traveled all around the world recording key moments, photos, and images in the golf world.

Do I like what I do? No, it's really more I LOVE what I do!

And to have had the opportunity to do it all these years. These memories will live on, beyond the fairway, and past my time etched in the cover and its timeless images, the soul of this book.

They are and have been my LIFE and are some of my most cherished pleasured moments of my life.

But I am surely not through. This is just a celebration of all the fun I had, and an acknowledgment to all those wonderful moments and the great friendships I made and still have. And I look forward to much more. I love all these Men and Women who made golf what it is and more today! It's what I do: Make you happy, via the lens, with my pictures.

Enjoy my celebration of fifty years in the business pictured in this book. It's so unbelievable. I can remember most all these moments like it was yesterday.

And I got to do this for a living all these years. How fortunate and lucky I am. In looking back I am glad I went up the pole at the high school football game, and that I took that assignment with *Golf Illustrated*.

I hope you enjoy *Beyond the Fairway*. It's been my life's work and I am very proud of it. The images are priceless and speak for themselves and invite you to journey back with me through my lens and camera, back to a special era in golf when golf was king, had a king (Arnold Palmer), the two greatest golfers ever (Jack Nicklaus and Tiger Woods), and a Big Three (Arnold, Jack and Gary) and reigned supreme.

News Flash: There's some cool stuff just around the bend that I'll be doing in in the future. One is an all-new audio podcast named *Beyond the Fairway* with my publisher and good friend, Bob Cisco, who was the co-host of *All About Golf* and *Tee It Up Golf*, a national golf radio show several years go. He's also one of the best putting and performance coaches in golf today.

ONE

Paul Lester

In 1976, me, with the perm, with a very young Ben Crenshaw. We have been friends since we both got our start in the business. The photo says it all.

Early on in my career, *Golf Illustrated* magazine sent me on assignment to Via Verde Country Club in San Dimas, California to do a story on Al "Mr. 59" Geiberger. When we got started, he turned to me and said, "You stand right over there and I will chip balls over your head." Shocked, I said, "Seriously? You're going to hit me." Mr. 59 just laughed, "I'm not going to hit you."

Here I am in San Antonio, Texas, pausing for a fellow photographer.

The Rat Pack, the movie, *Ocean's 11*. My Dad, Buddy Lester, second in from the left, is credited with the start of my golf photography career. Dad loved golf and played in many celebrity events. He encouraged me to bring my camera to tournaments, in case somebody needed photos. The rest is history. I love my Dad, there was never a dull moment with him.

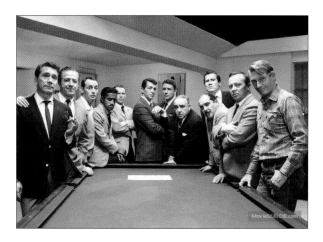

Walking down the fairway, next to my man, Gary Player. I'm so lucky to be able to walk inside the ropes at special events. I love my job.

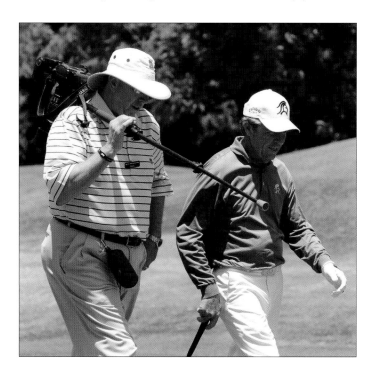

Here's me, Beyond the Fairway.

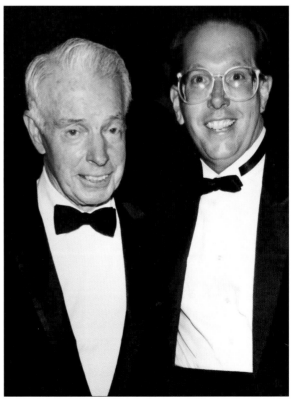

Me and Joe DiMaggio. "Joltin Joe" played in many LPGA events.

Young Jillian Lester hanging with her friend, golf great Fred Couples.

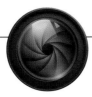

Legends of Golf

Two of golf's greatest icons side by side, Arnie and Jack.

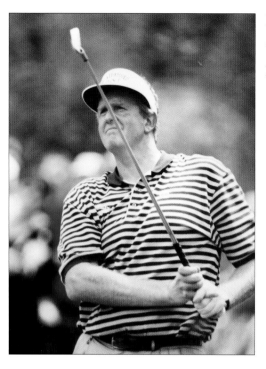

No matter what you hear or read, Colin Montgomerie is a great person, and a great player.

Legends in Houston. These golf giants gathered annually for the Insperity golf event. Photographing some of these guys is where my life started. It amazes me when I think about how lucky I have been to know these great men and golfers. Standing: Lee Trevino, Gary Player, Jack Nicklaus, David Graham, Dave Stockton. Seated: Don January, Gene Littler, Arnold Palmer, Miller Barber.

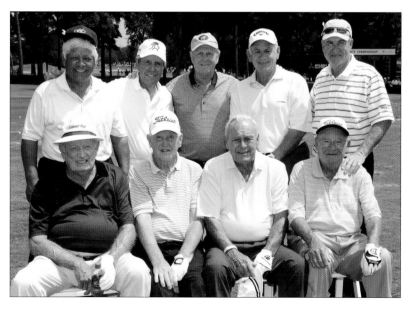

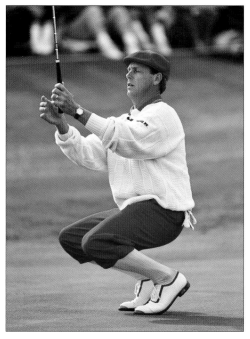

Payne Stewart, the man. We lost him way too early. He was a golf legend and classic all to himself. An incredible personality. Payne and I spent many days and nights together at outings and Pro-Ams. A fond memory of Payne happened during an outing we were both at in Florida. I had to get out to the course early. As I am getting ready to go down the hallway towards the golf course, Payne was down the way, eating breakfast. He sees me walking by and he screams out in his southern accent, "Paulie! Where are you going?" And I said, "Well, Payne I'm headed out to the driving range to set up." He replied, "You better get in here right now and have breakfast with me." I insisted that I needed to get to the course to set up. He said with a laugh, "Paulie, nothing's going to start until I get there." So I sat down and had breakfast with him. He always treated me like a friend. It's not the same without Payne.

Legendary golfer Byron Nelson pauses for a drink at a water fountain during the Bogie Busters Golf Tournament in Dayton, Ohio. Byron was a very gentle man and loved by many. He was a true legend.

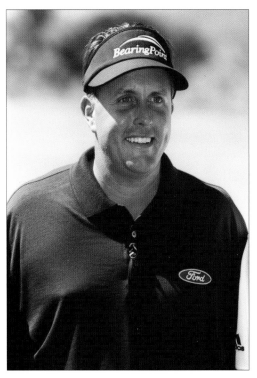

Phil Mickelson. When I work with Phil, he always asks me if I have everything I need. He's so nice and caring, and always goes out of his way to say hello. Phil is great.

Jack with his namesake,
The Golden Bear.

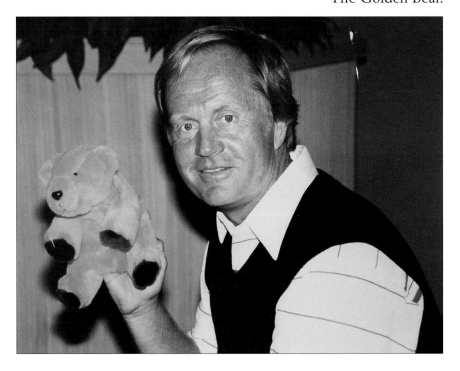

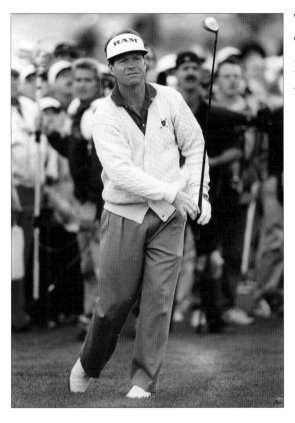

Tom Watson, a perfect swing. Tom's caddy, and my friend, Bruce Edwards, made quite a team. We miss Bruce every day.

A famous pairing of golfer and caddy. Herman Mitchell was a huge man. I was friends with him and he was a fun guy. All he wanted to do was win. But being with Lee Trevino was a laugh a minute.

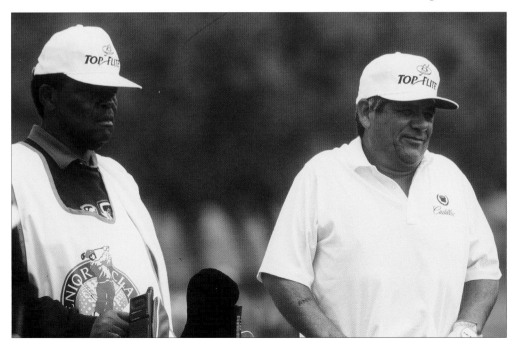

Johnny Miller and I have traveled all over the country together to Pro Am events where he was the star and I was the photographer. All those years of traveling together I never heard him utter a bad word.

Sir Nick Faldo giving directions on the golf course. When I worked with him, he would always ask me if I was going to shoot some "snappies," a term they use in England for photographs.

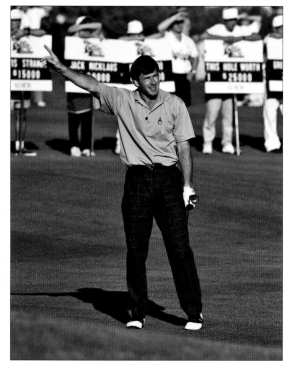

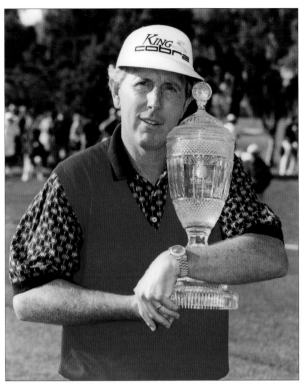

Hale Irwin hugging a trophy after one of his many victories. Hale, a fierce competitor who never liked to lose.

John Daly, a truly wonderful human being. (Note: Young Phil Mickelson in the background.)

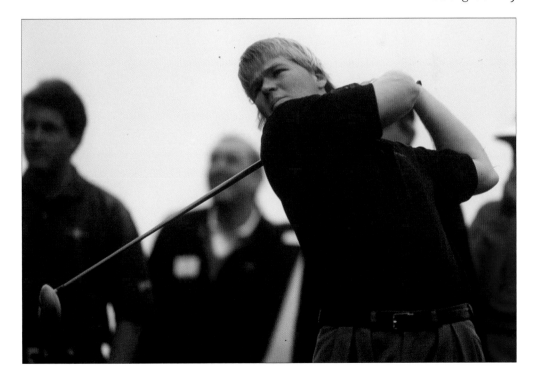

Sergio Garcia and Lee Trevino, teamed up together. The photo tells it all. This was a great event with lots of one liners.

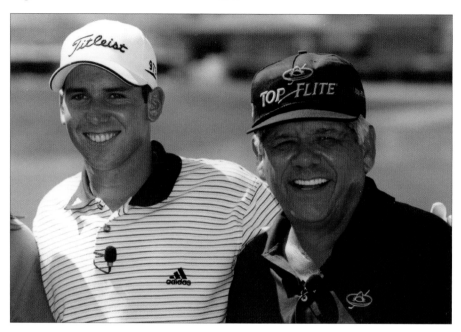

I ran into these legends in 1987. It was so fun to see them together because I know that Byron was Ken's hero. Byron and Ken spent many hours at Bel Air Country Club in Los Angeles, where I was the photographer.

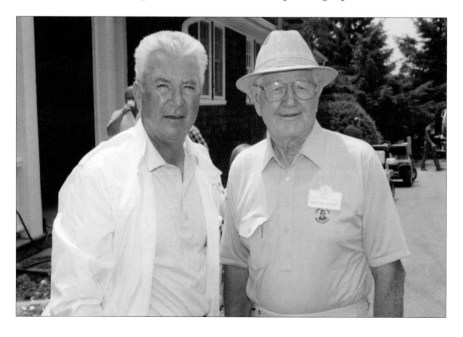

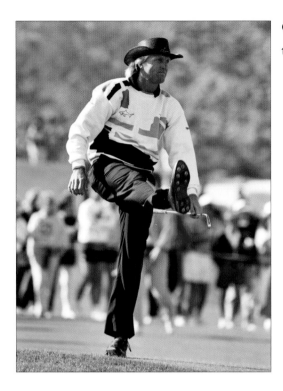

Greg "The Shark" Norman urging the ball over the lake.

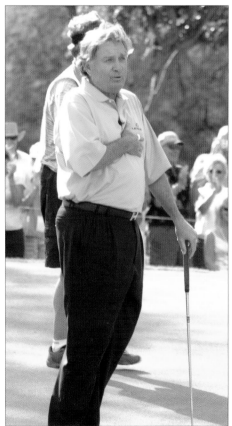

Ray Floyd reacts to another putt going in. He was from Chicago where my Dad was from and they were friends. Ray was intense and tough, but also fun. He and his wife Maria always treated me well.

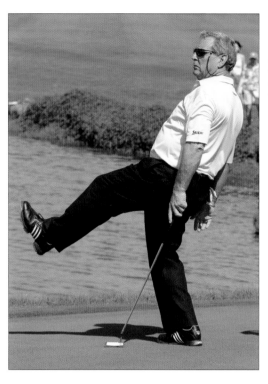

Fuzzy Zoeller, one of my favorites, great player and friend. I spent a lot of time with Fuzzy. Following him on the fairway was never disappointing for anybody.

No matter what you have heard or read, Jack and Arnold loved each other.

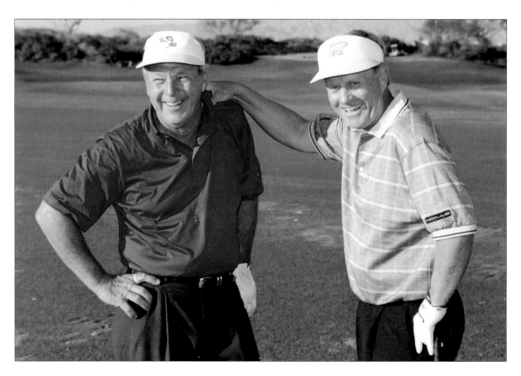

THREE

Golf Celebrities

Bob Hope started the first PGA Celebrity Tour called the Bob Hope Desert Classic. His friend Dinah Shore started the first LPGA Celebrity Tour, the Dinah Shore Invitational, which I was fortunate enough to photograph for 35 years.

Bob Hope loved golf and was a good player.

John Daly rocking out with Jake Owen.

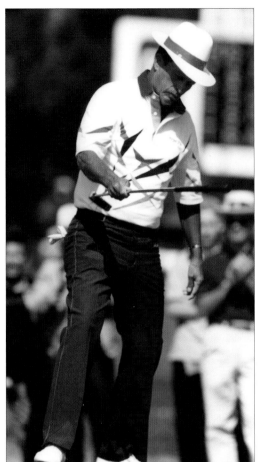

A giant showman. When Chi-Chi Rodriguez was on the golf course, we all knew we had to get the famous "sword-dance shot." We knew that when that first birdie came, he was whipping out that putter. If you wanted to have a great time at a Pro-Am, everybody knew follow Chi-Chi. He had the best one-liners ever. One I won't ever forget, the time a Pro-Am player hit a bad shot and he yelled out, "Don't blame Desenex."

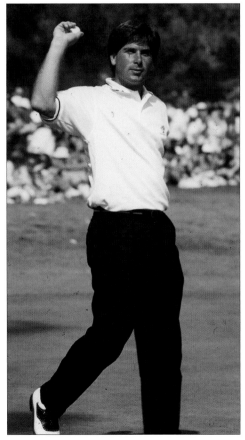

Fred Couples acknowledging the crowd. Everyone loves Freddie.

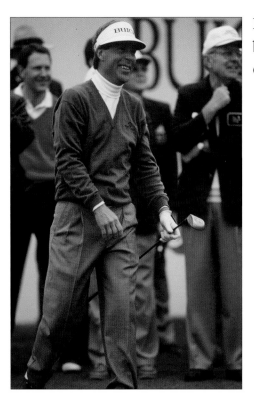

Ben Crenshaw is so kind and sweet, but a fierce competitor. We all love Gentle Ben.

Don Drysdale was a Hall of Fame pitcher for the Dodgers that I had known since I was 10 years old, and was a good friend of my Dad. Annie Meyers was a Hall of Fame lady basketball player. Annie said she never thought she would get married, but she met Don and the two fell in love. I was fortunate enough to be chosen to photograph their wedding, and later Don started the Don Drysdale Hall of Fame Golf Classic. This tournament brought together hall of famers from all sports. I still see Annie all the time, and not a day goes by where we do not think of Big D.

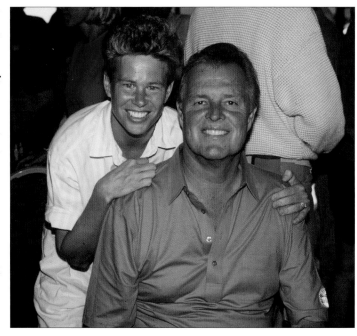

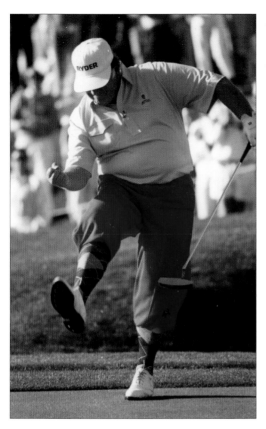

A very animated Billy Casper was a nice, gentle, fun-loving guy, and when on the course, I could always rely on him to give me a great shot.

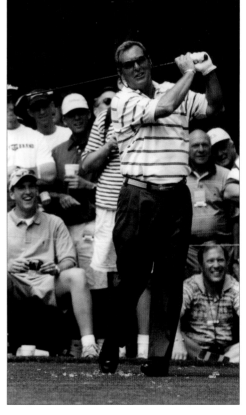

Notice the crowd cracking up behind him. Fuzzy Zoeller can play and crack jokes at the same time. Note the ice on the ground. His partner, John Daly, threw ice at him during a practice round. Fun, fun, fun!

Dave Stockton was intense, but a great player and a champion. He was at some of the first corporate outings I had ever done. He was a fun guy, but he knew what he wanted and he let you know it. During a tournament at Wilshire Country Club, I was following him down the 18th hole, when I came to a stop near where his family was standing. Dave stopped play to call me and his son over to him. "Paul, I need a photo of Ronnie and myself for the Father, Son Tournament Program," Dave said to me from the fairway. I said, "OK, Dave, we will do it after the round." "No, let's do it now," Dave replied back. Not being one to argue with Dave, Ronnie and I walked right under the ropes, shot the picture, and Dave carried on.

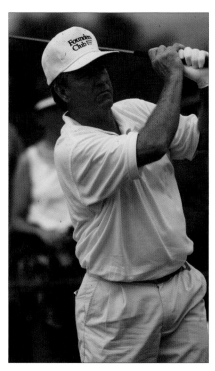

In Minnesota, at the Ryder Cup in 2016, Bill Murray was in attendance,

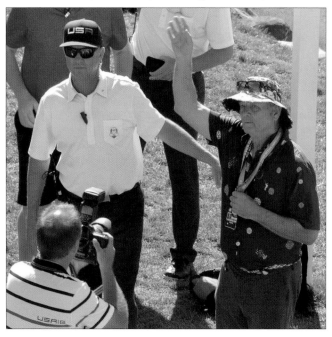

laying low, in the background, trying not to make a scene. I was hanging with him most of the day. But then, Davis Love III, the captain of the U.S. Team, spotted Bill and asked him to come down to the first tee to greet the team. Here's the shot I got of him waving to the crowd on the first tee with Davis Love III.

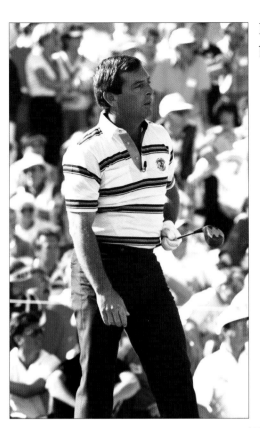

Note the Persimmon wood and strong body. A young Fuzzy Zoeller.

Charlie Sifford was the first African American to really play on the golf tour. Always with a cigar in his mouth, Charlie was good friends with my Dad and other celebrities. He was a great golfer, but also fun-loving.

Howard Cosell and the singing cowboy, Gene Autry. It was great to have Gene show up for the day with the All-Americans. He also owned one of my favorite baseball teams, the California Angels.

Mac Davis, Jim Nance, and Clint Eastwood participating in a special gathering of members at the Bel-Air Country Club, in Los Angeles. Great members, great celebrities everywhere. I am so lucky to be the club photographer.

Check out those shoes. Doug Sanders was a colorful person and a great player. Whenever I saw him he always wanted photos. A very classy guy. He was one of a kind.

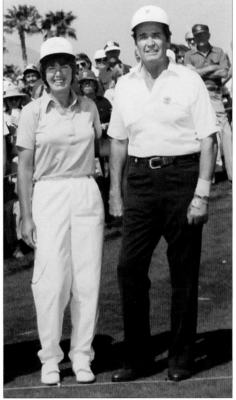

James Garner was a friend to all golfers, including Pat Bradley. I was fortunate enough to photograph Pat's Hall of Fame Ceremony in Boston.

Jim Nantz poses for a photo with his hero, Vin Scully, the voice of the Dodgers for 61 years. I know Jim loves this one.

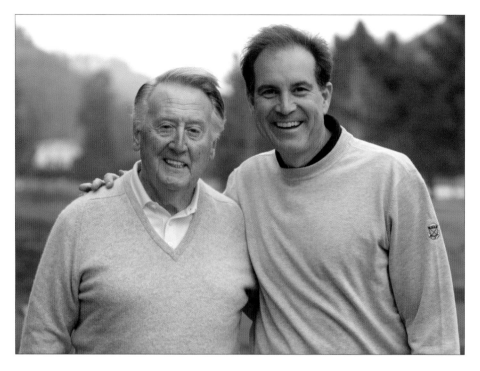

My guys, Robby Krieger, the Doors guitarist, who wrote "Light My Fire," and Scott Medlock, top artist for sports and celebrities, both my great friends, were on the board of the St. Jude's golf event.

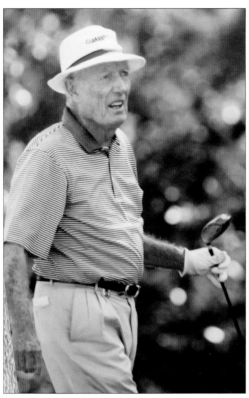

Slow moving, slow talking, Don January was fun loving and a great player. He won the first senior tour event I ever covered in San Antonio, Texas.

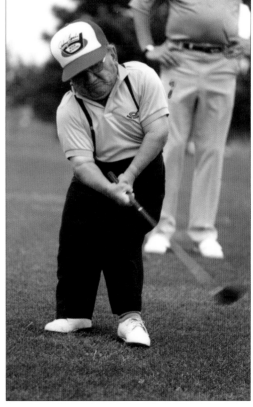

Billy Barty tees off at the Bogie Busters Golf Event in Dayton, Ohio. A dear friend to me and my Dad, Billy Barty gave me my start at my first charity golf event at the Billy Barty Little People's Golf Tournament. I loved Billy, he was such a classic. He was a talented actor, comedian, and showman. And the first spokesman for Little People. Billy was a little person, but he was a big part of my life.

Golf Classic

Here are the two people who made golf. What a conversation. Jack trying to get some advice from the King?

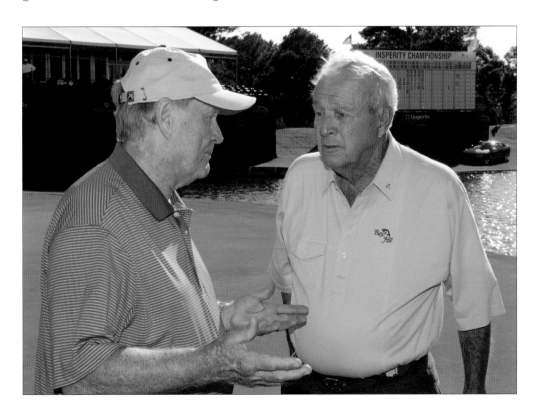

Jack, known as the best golfer ever. Tiger, known as the best golfer ever. Here they are together, the two best, ever.

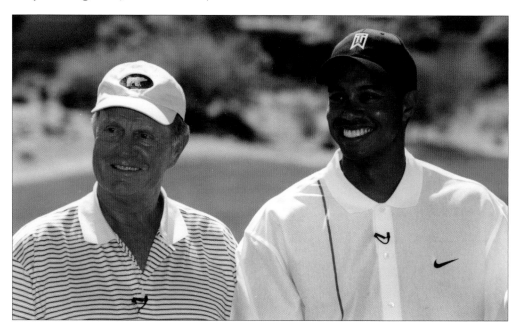

Two fun-loving golf legends and celebs, Freddie Couples and Annika Sörenstam.

This is the 18th hole at Riviera Country Club.

Johnnie Miller in the 1970s. Wow!
Look at those pants. I think my Dad
might have had some like that too.

A colorful Payne Stewart always wore the best clothes.

Can't get enough Arnie.

These guys loved life. Arnold, Lee, Miller Barber.

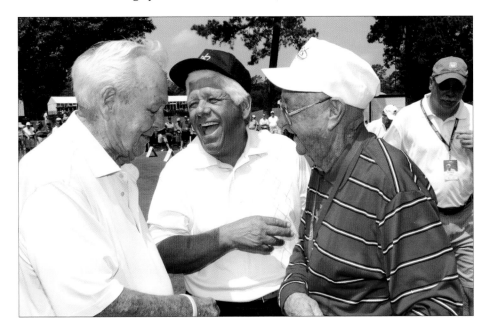

Love this one. After a long morning, Jack took a short nap on Lee's shoulder. What a perfect photo.

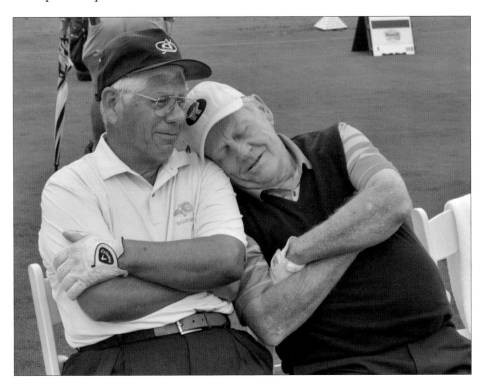

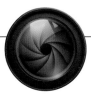

The Big Three: Arnold Palmer, Jack Nicklaus, Gary Player

Talk about the right place at the right time. This classic image of legendary golfer Arnold Palmer greeting his longtime and dear friend Gary Player is moving, to say the least. It is no secret the love and admiration so many had for Arnold and Gary, but the two thought as much of one another. The two friends were only able to see each other just a few times a year, so to capture this genuinely happy reunion between two titans of golf was unforgettable.

Arnie and his Army.

Without a doubt, one of the last photos of The Big 3. People always ask me how I got a smile out of these three guys. I was lucky, they were my friends and they gave me great smiles. Not to mention, I am sure they were throwing a zinger or two my way. That may be the real reason for the laughs.

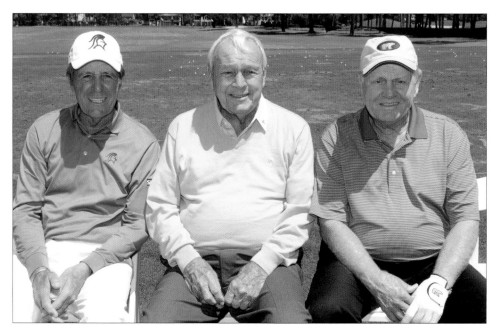

Arnold Palmer: "AP" The King of Golf

Arnold's last event on the
Champions tour. Tom Kite
makes sure the King stays on
track.

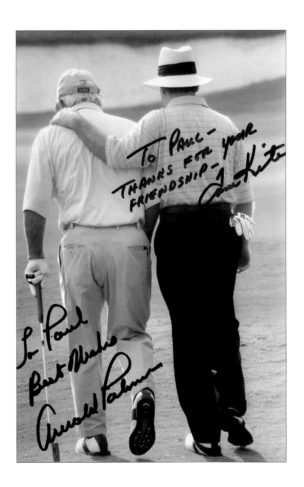

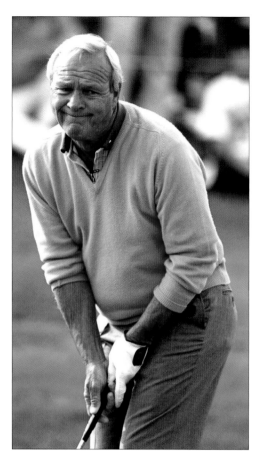

Arnold, in one of his signature sweaters, just misses.

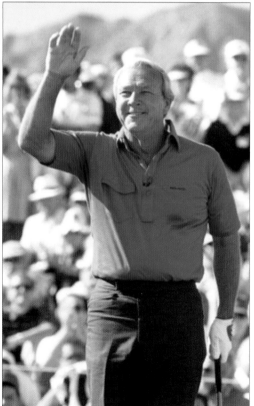

Arnie waving to his "army."

Arnold always attracted the Camera.

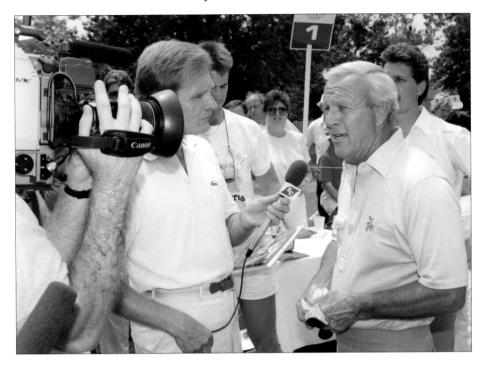

Arnold Palmer holding Jim and Courtney Nantz's baby. Jim loved Arnold. I was so lucky to be there to get this shot of the Nantz family. One of the first photos of their new baby.

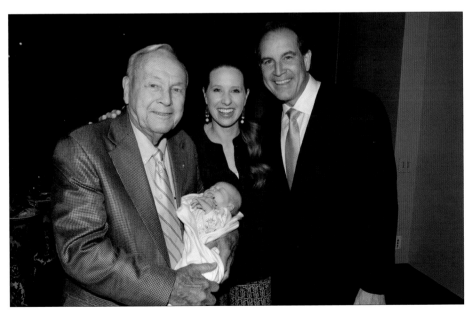

SEVEN

Jack Nicklaus:
The Greatest Golfer of the Century

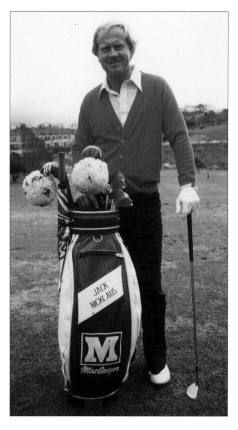

Jack Nicklaus with the MacGregor Bag in the 1970s. He put MacGregor Golf on the map.

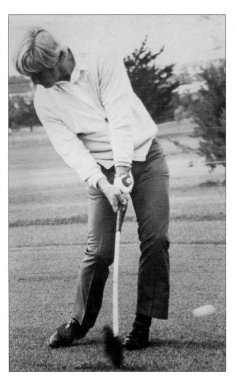

Jack in the 70s, in an old black and white. Look at that swing.

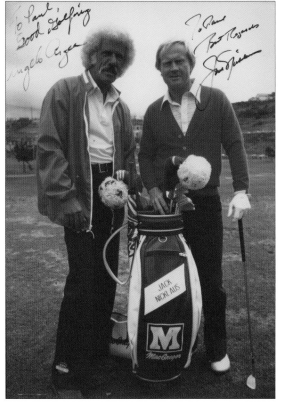

Jack Nicklaus and Angelo Argea, another great caddy and player team from the old days. I was friends with most of the caddies, and even spent time in hotels and restaurants with them. I learned early on that getting to know and being friends with the caddies leads to great relationships with the players. That is key.

You can't help but smile when Chi-Chi is around. I caught them on the range, they both wanted a copy of this one.

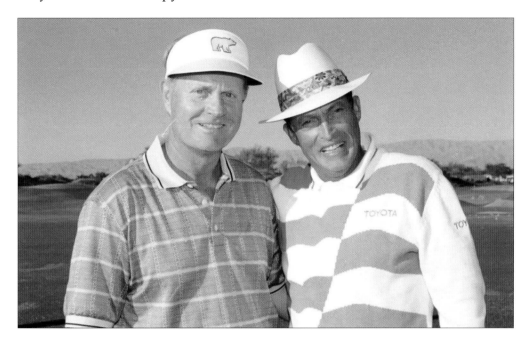

Jack, how many times do I have to tell you. You can only use ONE ball at a time.

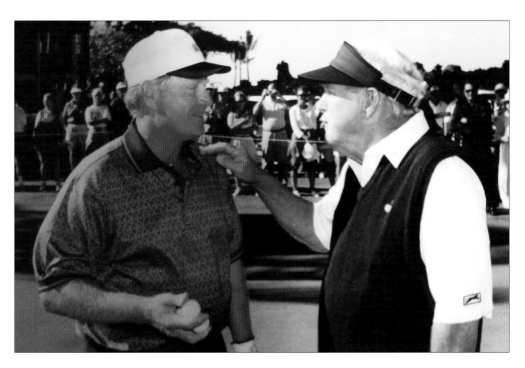

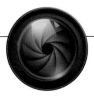

Gary Player

Bernhard Langer getting some words of wisdom from Gary Player.

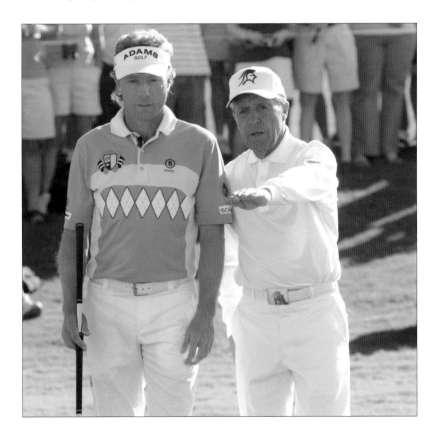

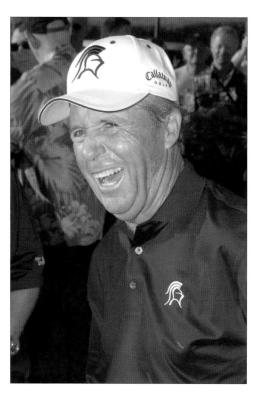

This is Gary smiling, happy, but intense and always working on his swing.

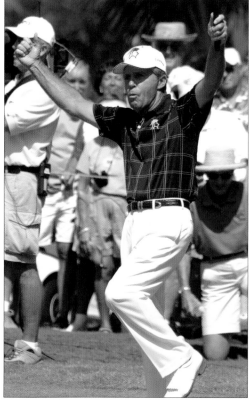

Gary Player celebrates with the best. He always gives me great reaction shots.

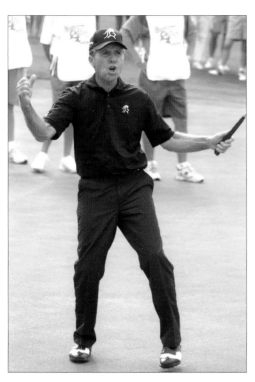

The true Black Knight.

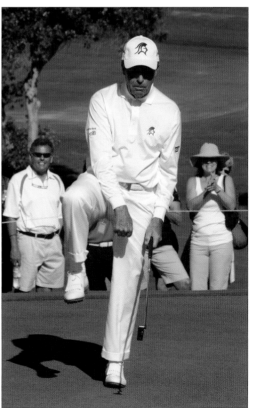

Gary Player in all white,
still so flexible as you can see,
with the high kick.

Tiger Woods: Golf's Greatest Modern Player

Amateur golfer, sixteen-year-old Tiger Woods's first time in a Pro golf event at Riviera Country Club in 1992. This photo is now a plaque on the wall in the Pro Shop at Riviera. It still hangs there today.

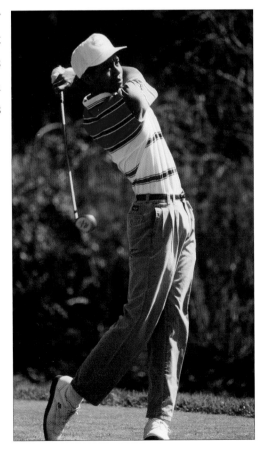

Watching Tiger become the man he is has been very special. When he is working I give him plenty of space and when he is off the course we have loads of fun.

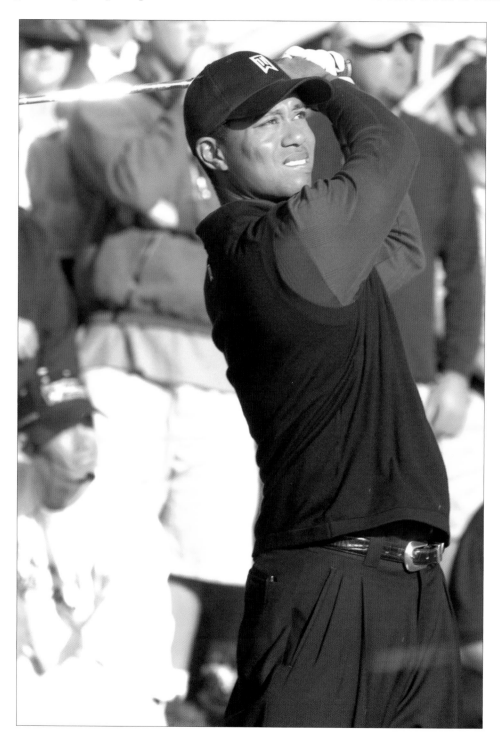

Tiger and Fred, both young, great thinkers and Players.

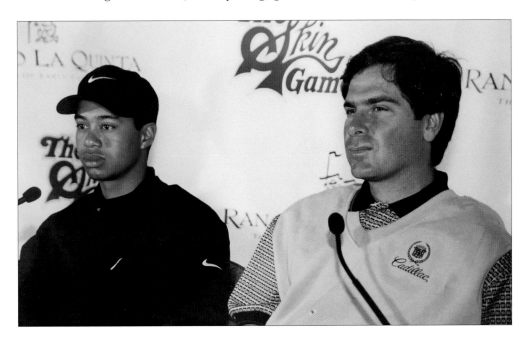

Friends of Golf. Bel Air Country Club 1991. "Little Pro" Eddie Merrins, Chi-Chi, Young Tiger, Byron Nelson, Dave Stockton.

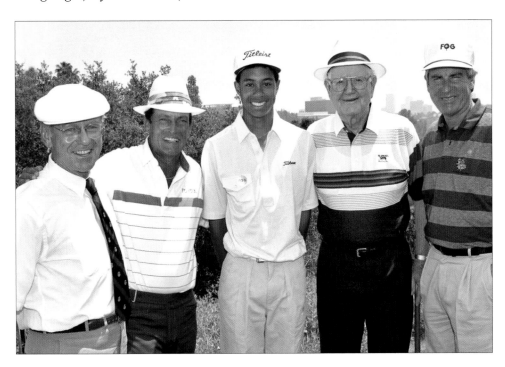

What an honor to watch Earl Woods guide Tiger thru his young life.

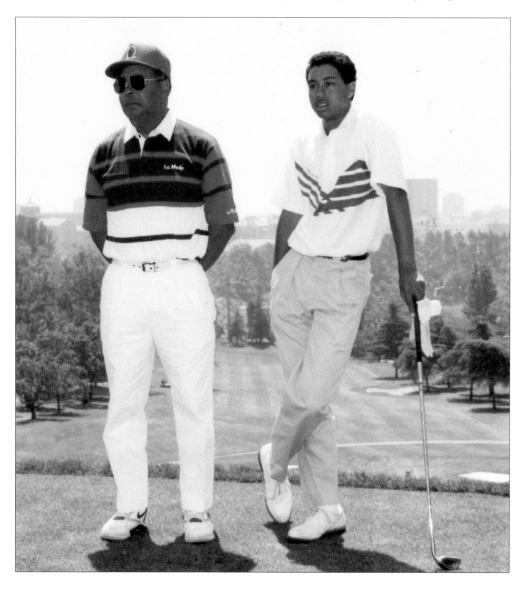

TEN

Ben Hogan

This simple photo is the inspiration for this book. I shot this photo as Jack was coming off the course at the Centennial of Golf Pro Am, in New York City in 1988. It's a rare picture of Jack Nicklaus and Ben Hogan. I presented this photo to Jack and Barbara 30 years later, at which time Barbara told me she had never seen it before. That's when I thought, I wonder how many other photos I have that go way back, that many have never seen? Thus, *Beyond the Fairway* was born.

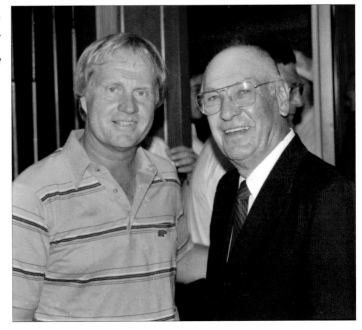

Sam Snead and Ben Hogan cracking up. Sam told some very funny stories.

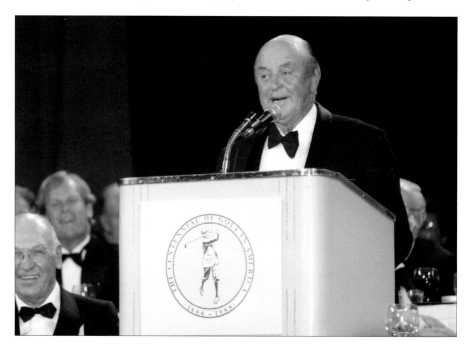

The Hawk, tougher than nails.

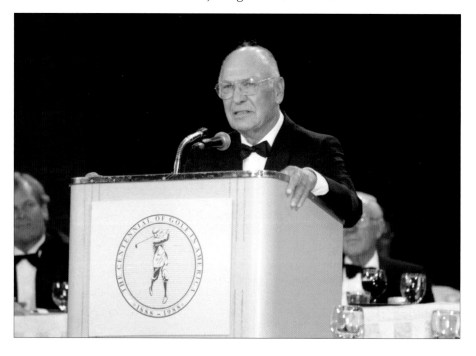

A somber moment. The widow of Ben Hogan, Valerie Hogan, stands with famous LA Times sports writer and Pulitzer Prize winner Jim Murray, next to the bronze statue honoring Ben, after a special unveiling at the U.S. Senior Open at the aptly named Hogan's Alley at Riviera Country Club.

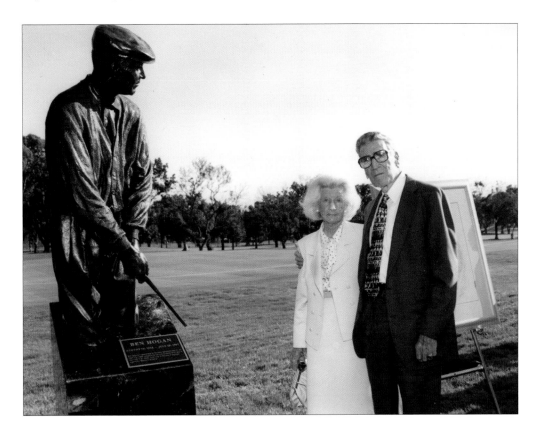

Women Pro Golfers

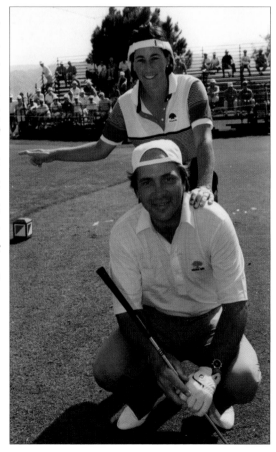

Hats on backward, Amy Alcott, Hall of Fame golfer, was having a bit of fun in a posed shot with her good friend, Hall of Fame baseball catcher, Johnny Bench, during a break at the Dinah Shore Golf Tournament. This is a great picture because both Amy and Johnny were such good friends. But also, seeing this Hall of Fame baseball player in his catching position in golf clothes on the golf course, made this moment memorable.

Amy Alcott, Hall of Fame golfer, remains a great friend to this day. I have had the privilege of watching Amy grow and succeed in her career and even had the extreme honor of photographing her at her induction into the Hall of Fame. Pictured is one of her younger photos, evidence of Amy's long, successful career in golf.

At the Nabisco Dinah Shore Invitational, a lucky day for Patty Sheehan, to play with Bob Hope and President Gerald Ford during the celebrity portion of the golf event. Patty is a longtime friend of mine. I was fortunate to be able to photograph her induction into the Hall of Fame and we are still great friends today.

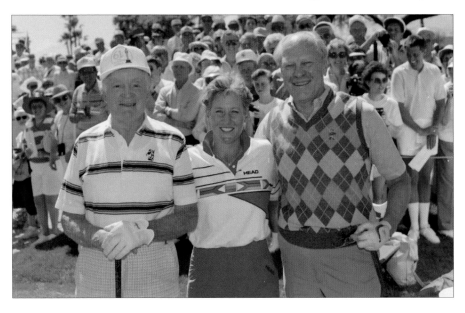

When Donna Caponi played, you knew who was in charge. I've known Donna since I was young. Her dad was a golf teacher in Studio City, California, and was friends with my Dad. Donna and I are still friends today and I see her often.

You don't want to play these two in a team match. Dottie Pepper and Juli Inkster. They will destroy you. Two of my best friends. The pair were intense, great players, and fun to be around, but they hated to lose.

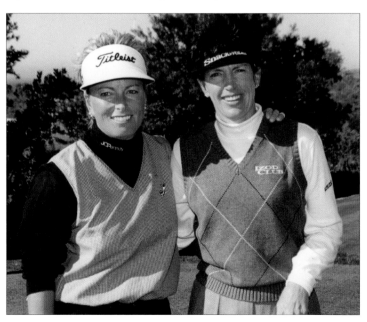

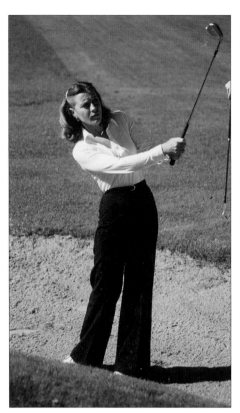

Jan Stephenson always looked sharp on the golf course.

JoAnne "Big Momma" Carner was one of the most colorful lady golfers. She never disappointed in giving us great reaction shots. Note her Snoopy sweater. JoAnne played several events with Charles Schulz.

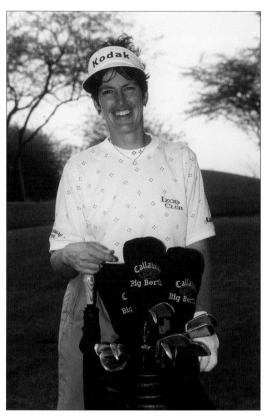

Juli Inkster, a great golfer, mother, wife, and a huge San Francisco Giants fan. Me being a Dodger fan always keeps things lively.

Kathy Whitworth is a great lady and queen of the tour. She has more wins than any other golfer.

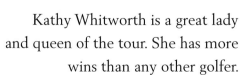

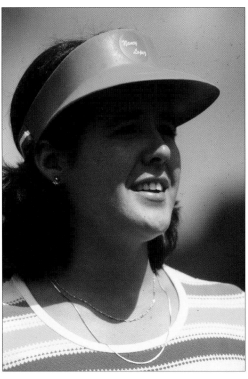

So no one would forget her name, Nancy Lopez had it written on her visor. She won nine times in 1978.

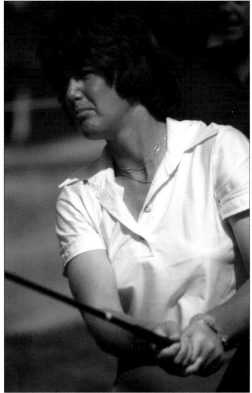

A young Pat Bradley: Winner, competitor and a friend to all.

Patty Sheehan and President Gerald Ford looking down the fairway. Great smiles. Note my friend, Harpo the Clown, in the background.

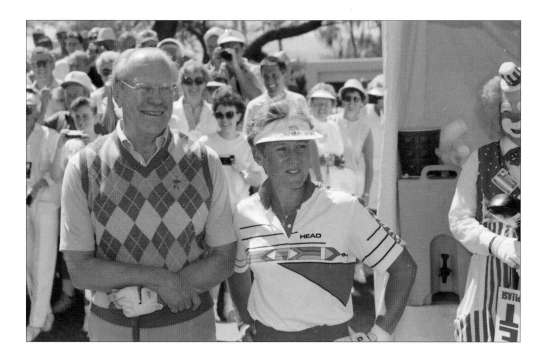

TWELVE

Golf Presidents

Take cover! Balls were flying everywhere! President Bill Clinton (far right), was the first sitting president to play in a PGA Tour event. He is seen here at Indian Wells Country Club, Indian Wells, California with Presidents George H. Bush and Gerald Ford.

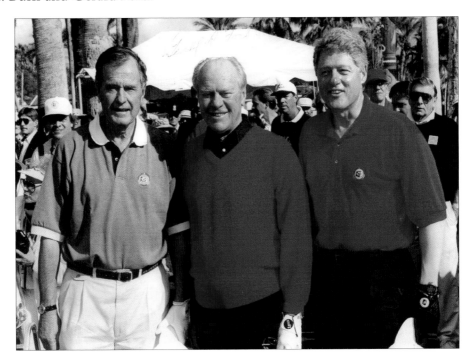

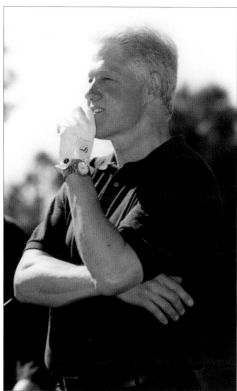

President Bill Clinton in a classic pose, watching a golf shot. The President had a tour event named after him. It was the Humana Challenge to benefit the Clinton Foundation.

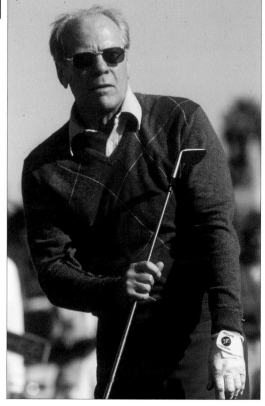

President Gerald Ford follow through. President Ford was very important to golf. During his time as President, he showed the world the great game of golf.

My favorite. The President, The Bear, and both Barbara's.

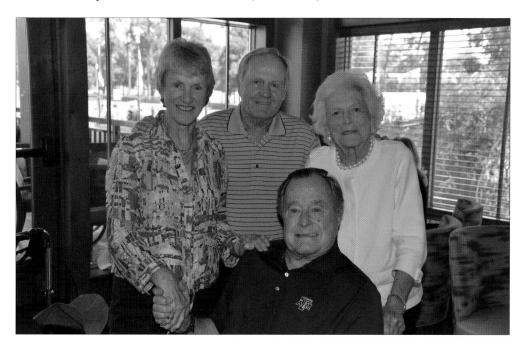

The President and The King. Arnold taking President George H. Bush for a ride. As I noticed them driving by, I grabbed my camera, and got lucky, the President was looking right at me.

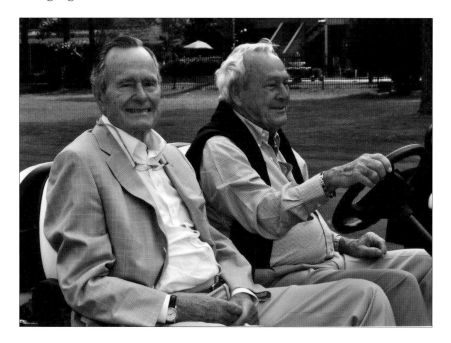

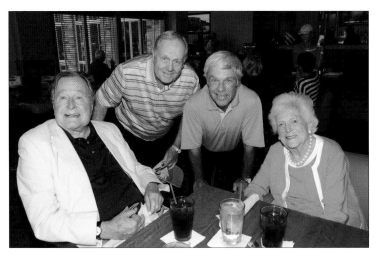

President George H. Bush was having a bite to eat with wife Barbara in the clubhouse in Houston when President Bush's two friends Jack Nicklaus and Ben Crenshaw stopped by to say hello. I was there with my camera and shot the very special photo. Ben from Texas was good friends with the Bush family. Of course Jack, they all know Jack.

At a VIP meet and greet President George W. Bush smiles perfectly with Kit and Arnold Palmer. I was always shocked to see how tall and in shape President Bush was, whenever he walked into the room. As I started to photograph the line of guests with President Bush, one of his assistants asked me to only take one photo each. This made me worried because I was afraid someone's eyes would be closed. When I looked through the pictures, I noticed that President Bush had a perfect smile and his eyes were open. I mentioned it to him and he said, laughing, "Paul, this isn't my first rodeo." I replied, "Yes, I guess you're right."

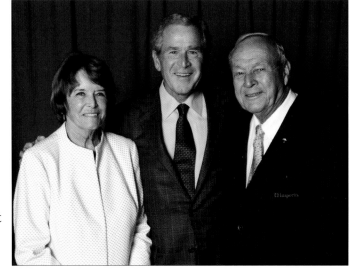

The Skins Game

It was the Seniors Skins Game in Hawaii. The boys loved playing there and the views are great. I have worked in Hawaii for 30 years, and it's always fun, but lots of work. It's no walk on the beach; a golf course is a golf course.

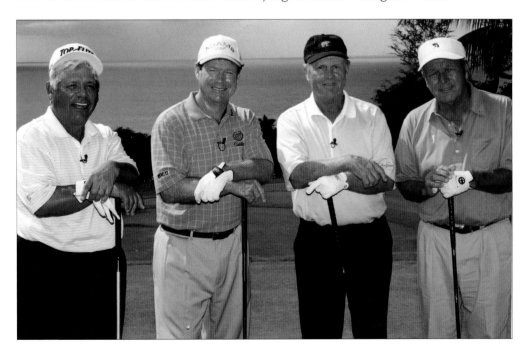

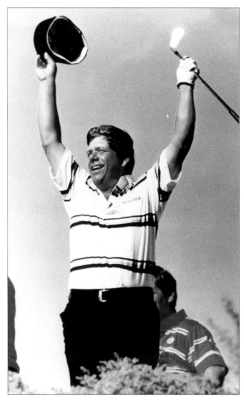

In 1987, this hole in one by Lee "Super Mex" Trevino, at the Stadium Course PGA West in La Quinta, California, put the Skins Game on the map. The hole in one was worth $175,000.

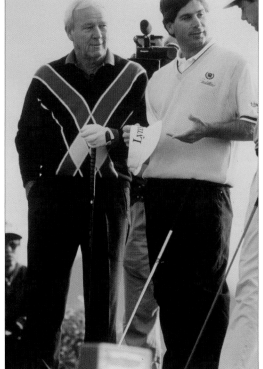

Longtime Skins Game participant Fred Couples teeing it up with the King.

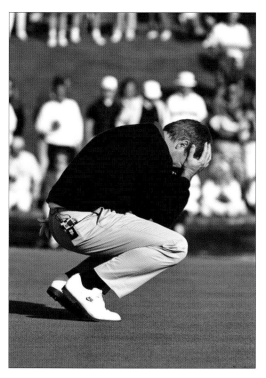

Curtis Strange putting at the Skins Game. We traveled all over the country doing corporate outings. Love Sarah and Curtis.

Greg Norman in a Skins Game, playing a hole for $200,000. Even for the Shark, this was a big shot.

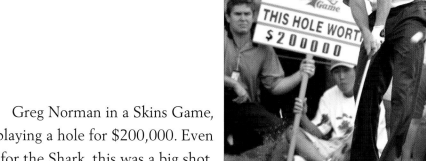

Through the Make A Wish Foundation, a young boy wanted to spend time with his hero Payne Stewart, at a golf event. Payne invited him to the Skins Game at Big Horn Golf Club in Palm Desert, California in 1992. The boy's doctors warned him prior to the event that the trip could be fatal, but he made the trip anyway. Payne gave the boy a pair of his famous knickers and he won the golf event that day, earning the trophy pictured here. Shortly after the boy returned home, he passed away, and the trophy Payne won that day was buried next to him.

John Daly in 1991 at the opening party of his first Skins Game. I walked into the cocktail party early, but John was already there. He greeted me with this pose, and we have been great friends ever since.

One of the great television moments in golf, Fred Funk paid up on his dare that Annika Sörenstam, couldn't outdrive him. On the fifth hole, Annika did just that. Fred unzipped his golf bag, pulled out his skirt, and filled his end of the bargain. Here's one of the most iconic Skins Game moments I have ever photographed.

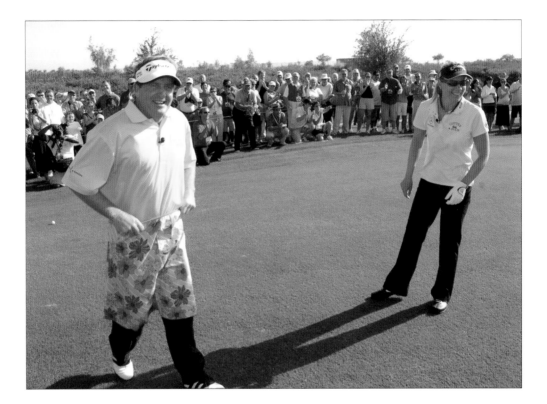

The Centennial of Golf Awards

New York City, 1988, I was the lone photographer at the Centennial of Golf, a one-time, televised event to name the Player of the Century. In attendance were all the golf greats, including Ben Hogan. We were all on edge with Ben there, as he was known as a no-nonsense kind of guy. All it would take is one wrong move and he might leave, ruining the whole TV show. Just my luck, Jan Stephenson, a hall of fame golfer from Australia, also known for her risqué photo shoot in a bathtub just weeks prior to the big event, asked me to take a photo of her with Ben. I knew there was a chance that he could say

no, and even go so far as to leave the event because of my request for a photo. It could have also ended my career. But I asked anyway. Lucky for me, before I could even finish asking, he said, "Bring her over!"

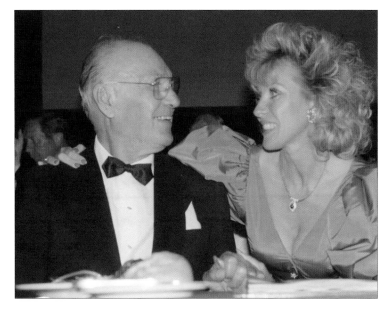

Jack Whitaker emcees the Centennial of Golf, probably the greatest gathering of golf legends, at the Waldorf Astoria in New York City.

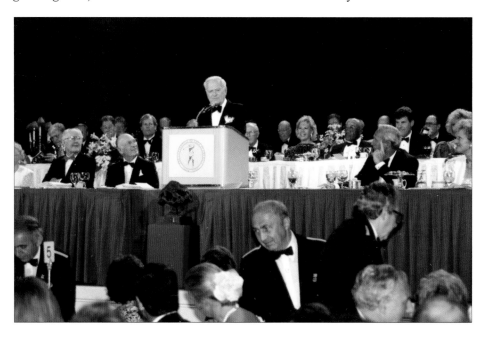

Sam Snead and Ben Hogan cracking up. Sam told some very funny stories. Note the bow tie.

A young Nancy Lopez captivates the audience while speaking at the Centennial of Golf event.

Follow up to Snead speaking. This shot, notice his tie. The clip-on bow tie fell off during his speech. Everyone, including him, cracked up.

The Ryder Cup

U.S.A. Ryder Cup in Wales, 2010. My friend Corey Pavin was captain of the team. Corey and his family are longtime friends. I shot his charity event, The Corey Pavin Big Brothers Big Sisters Golf Classic, run by his mom, dad and two brothers.

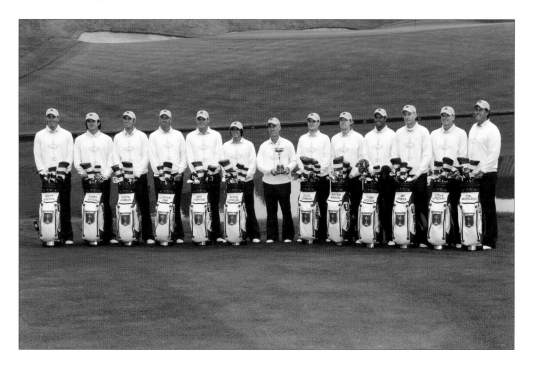

Ryder Cup flags: Patriotism at the Ryder Cup is always over the top.

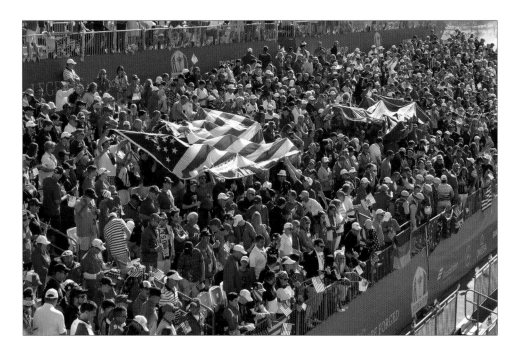

At the 2016 Ryder Cup at Hazeltine, the first tee is always packed like all Ryder Cup events.

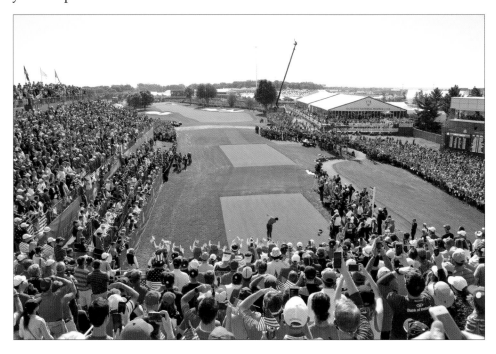

About the Author and Book

From the Masters to the Skins Game, Paul Lester has been a prominent golf photographer for 50 years, covering career highlights of Tiger Woods to Arnold Palmer and Nancy Lopez. Introduced to the world of entertainment at an early age by his parents, Lael and Buddy Lester, Paul learned his craft at Columbia College in Los Angeles. His work has since been featured in *Golf Digest*, *Sports Illustrated*, and *ESPN, The Magazine*. Paul now splits his time with family and loved ones in both Los Angeles and Augusta, Georgia.

Bob Cisco is one of the most innovative and leading sports performance advisors in the game of golf today. He has worked with notable amateurs and top pros on today's pro tour as a PGA Tour instructor. He is the author of *The Ultimate Game of Golf*, *Perfect Balance Golf*, and *Ultimate Putting*.

Bob has been heard on over 2,000 radio show interviews talking golf, the mental performance area, effortless power, and the dynamics of swing motion and balance, reaching an estimated audience of over 300 million listeners.

His latest, cutting-edge research to determine the missing link in golf instruction is creating a rebirth of and return to key basics in the golf swing – swinging the club head and handle combined with new discoveries in the dynamics of balance and swing motion.

A true professional, Bob delivers the results desired. He is truly a pro's pro, master teacher of golf, and maker of champion golfers!

Contact Bob at bob@bobcisco.com, phone number is (818) 448-9694.

If you have a favorite photo or are interested in purchasing any of the pictures in the book, I have good news for you: I have more rare and memorable pictures of the golfing greats for you to select from.

Just use this link: paullester.zenfolio.com. Click on PORTFOLIO on the right side of the website to select the picture you want.

These make wonderful gifts for all your golfing friends.

All my best,

Paul

www.paullesterphotoonline.com

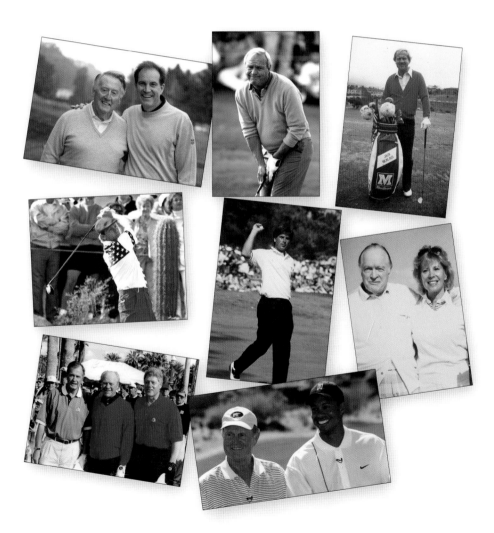